DRAW SCIENCE

Whales, Sharks, and Other Sea Creatures

By Nina Kidd

Lowell House
Juvenile

Los Angeles

Contemporary Books
Chicago

For Terrill

Reviewed and endorsed by Q. L. Pearce, author of *Giants of the Deep, Great Predators of the Sea,* and the *Nature's Footprints* series

Requests for such permissions should be addressed to:
Lowell House Juvenile
2029 Century Park East, Suite 3290
Los Angeles, CA 90067

Publisher: Jack Artenstein
Executive Vice President: Nick Clemente
Director of Publishing Services: Mary Aarons
Editor in Chief: Lisa Melton
Project Editor: Amy Hanson

Manufactured in the United States of America.

ISBN: 1-56565-013-1

10 9 8 7 6 5 4 3 2 1

CONTENTS

°50
e

Drawing Tips

This book shows you how to draw 24 different sea creatures. There are lots of different ways to draw, and here are just a few. You'll find some helpful hints throughout this book to help make your drawings the best they can be.

Before you begin, here are some tips that every aspiring artist should know!

- Use a large sheet of paper and make your drawing fill up the space. That way, it's easy to see what you are doing, and it will give you plenty of room to add details.

- When you are blocking in large shapes, draw by moving your whole arm, not just your fingers or your wrist.

- Experiment with different kinds of lines: do a light line, then gradually bear down for a wider, darker one. You'll find that just by changing the thickness of a line, your whole picture will look different! Also, try groups of lines, drawing all the lines in a group straight, crossing, curved, or jagged.

- Remember that every artist has his or her own style. That's why the pictures you draw won't look exactly like the ones in the book. Instead, they'll reflect your own creative touch.

- Most of all, have fun!

In drawing animals, it's always helpful to know the names of an animal's body parts. That way, you have a better understanding of your subject. For example, the illustration of the shark below shows you the names of its fins and other body parts. These terms are helpful, not only because they teach you something about the shark, but because they are also relevant to many of the other fish in this book!

As you learn more about animals (in this case, sea creatures), you'll see that certain kinds of animals are alike in many ways. For example, all fish have pectoral fins to help propel them through the water. But notice that similarities only go so far. When you compare the muscular pectoral fins of the shark with the feathery ones of the angelfish, you'll be able to see why these animals are both fish, but also why they are completely different species of fish. Recognizing the physical differences between similar animals will help you in your drawing.

Just as fish are alike in many ways, so are many of the other animals in this book. The squid, conch, and octopus, for example, are similar to each other, as are dolphins and whales. When you notice the similarities—and differences—between all these animals, you'll learn not just more about science, but about drawing, too.

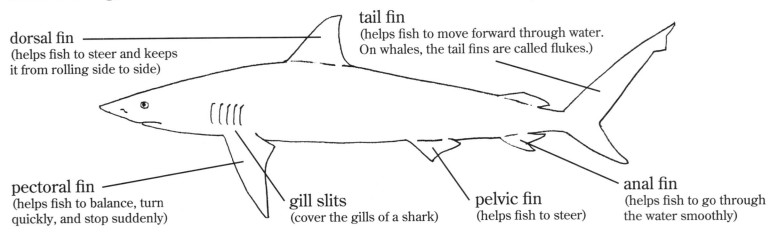

tail fin
(helps fish to move forward through water. On whales, the tail fins are called flukes.)

dorsal fin
(helps fish to steer and keeps it from rolling side to side)

pectoral fin
(helps fish to balance, turn quickly, and stop suddenly)

gill slits
(cover the gills of a shark)

pelvic fin
(helps fish to steer)

anal fin
(helps fish to go through the water smoothly)

What You'll Need

PAPER

Many kinds of paper can be used for drawing, but some are better than others. For pencil drawing, avoid newsprint or rough papers because they don't erase well. Instead, use a large pad of bond paper (or a similar type). The paper doesn't have to be thick, but it should be uncoated, smooth, and cold pressed. You can find bond paper at an art store. If you are using ink, a dull-finished, coated paper works well.

PENCILS, CHARCOAL, AND PENS

A regular school pencil is fine for the drawings in this book, but try to use one with a soft lead. Pencils with soft lead are labeled #2; #3 pencils have a hard lead. If you want a thicker lead, ask an art store clerk or your art teacher for an artist's drafting pencil.

Charcoal works well when you want a very black line, so if you're just starting to draw with charcoal, use a charcoal pencil of medium to hard grade. With it, you will be able to rub in shadows, then erase certain areas to make highlights. Work with large pieces of paper, as charcoal is difficult to control in small drawings. And remember that charcoal smudges easily!

If you want a smooth, thin ink line, try a rolling-point or a fiber-point pen, both of which come in a variety of line widths and fun, bright colors.

ERASERS

An eraser is one of your most important tools! Besides removing unwanted lines and cleaning up smudges, erasers can be used to make highlights and textures. Get a soft plastic type (the white ones are good), or for very small areas, a gray kneaded eraser can be helpful. Try not to take off ink with an eraser because it will ruin the drawing paper. If you must take an ink line out of your picture, use liquid whiteout.

OTHER HANDY TOOLS

Facial tissues are helpful for creating soft shadows—just go over your pencil marks with a tissue, gently rubbing the area you want smoothed out.

A square of metal window screen is another tool that can be used to make shadows. Hold it just above your paper and rub a soft pencil lead across it. Then rub the shavings from the pencil into the paper to make a smooth shadowed area in your picture. If you like, you can sharpen the edge of the shadow with your eraser.

Finishing Your Drawing

As you'll see with the sea creatures in this book, artists must use different drawing techniques to show scales, skin, shells, and fur to make their creatures look real. Here are some useful techniques for giving your drawings a natural look.

HATCHING

Hatching is a group of short, straight lines used to create a texture or a shadow. When you curve the hatching lines, you create a rounded look. This is handy when texturing an animal's curved fins, neck, or underside. When you draw the hatching lines close together, you create a dark shadow, such as with the underside of the elephant seal. For very light shading, draw the lines shorter, thinner, and farther apart, as shown on the seal's back.

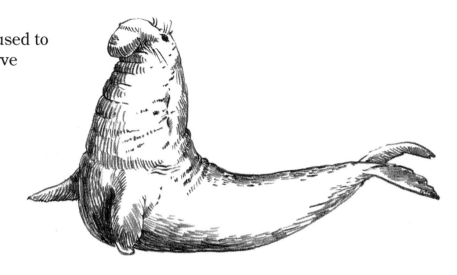

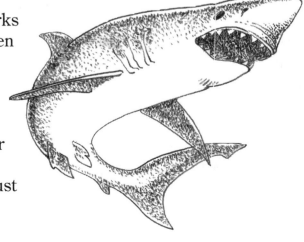

CROSS-HATCHING

This technique gives your animal a wrinkled, textured look. Start with an area of hatching, then crisscross it with a new set of lines. If you are drawing wrinkles on skin, make the lines a bit wobbly and uneven, just as creases in real skin would be. Take a look at the sperm whale to see how cross-hatching creates a rough-skinned look.

STIPPLE

When you want to give your drawing a different feel, try the stipple technique—and all you need are dots! This method works best with a pen, because unlike a pencil, a pen will make an even black dot by just touching the paper.

 The stipple technique is very similar to the way photos are printed in newspapers and books. If you look through a magnifying glass at a picture in a newspaper, you will see very tiny dots. The smaller and farther apart the dots are, the lighter the area is. The larger and closer the dots are, the darker the area. In your drawings, you can make a shadow almost black just by placing your stipple dots close together, as with this great white shark.

SMOOTH TONE

By using the side of your pencil, you can create a smooth texture on your creature. Starting with the areas you want to be light, stroke the paper very lightly and evenly. Put a little bit more pressure on your pencil as you move to the areas you want to be darker. If you want an area even smoother, go back and rub the pencil with a facial tissue, but rub gently! If you get smudges in areas you want to stay white, simply remove them with an eraser. Try this smooth texture on the sea otter, in combination with hatching as shown.

SPECIALIZED SHELL TEXTURES

Look at the queen conch to see another way to finish a beautiful drawing. A smooth texture is created on the inside of the shell by smudging pencil marks. A rougher look is created on the outside of the empty conch with dark, curved hatching lines.

Now that you're armed with the basic drawing tools and techniques, you're ready to get started on the sea creatures in this book. What's more, you'll learn as you draw! After each drawing step, you'll find some scientific information that not only is fun and interesting to know, but also useful when it comes to drawing.

Throughout this book, too, you'll find special Drawing Tips that will aid your progress. Last, at the back of the book, are extra techniques and hints for using color, casting shadows, and placing animals in a scene—in short, showing you how to make the most of your drawings.

The Bottle-Nosed Dolphin is a popular performer in marine parks and is probably

① For the body of your playful dolphin, draw a long, tapered form that is slightly thicker at the head.

The bottle-nosed dolphin seems to enjoy surfing on the bow waves of boats, and will sometimes follow boats for several minutes, catching their waves. This creature can reach a maximum length of 14 feet, 9 inches and can weigh over 600 pounds.

② Next add an oval for the beak and a half-heart shape for the tail flukes.

Believe it or not, many millions of years ago the ancestors of dolphins lived on land. When their descendants moved into the oceans, they still breathed air, but their bodies slowly adapted for life in the water. Their forelimbs evolved into flippers that helped them steer in water, and their hind limbs disappeared completely. Today, dolphins are among the best-adapted of the marine mammals.

③ To help your dolphin glide through the water, add the two backswept flippers and the dorsal fin.

Because dolphins breathe the way all mammals do—with lungs—they must come to the surface often. Leaping into the air from several feet below the surface enables the dolphins to gulp in air, and it actually takes less energy to leap in this way than to swim just under the surface. Even though these animals are excellent swimmers, they still can glide through the air more easily than they can swim against water.

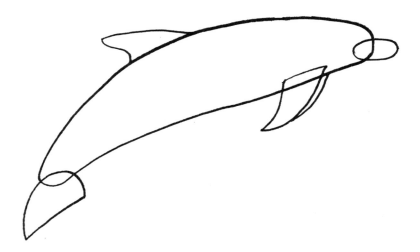

MORE SCIENCE: The bottle-nosed dolphin's natural predators are killer whales and sharks, who prey on sick or young dolphins that stray from the group.

the most familiar of the more than 30 species of dolphin. This intelligent seagoing mammal can be found throughout the world's tropical and temperate waters.

④ Indicate the eye and the curving shape of the mouth that makes the dolphin look as if it is smiling. Begin to add detail to the tail flukes, and sketch in the ridge that runs between them. Erase all the unneeded lines in the body, head, and fins.

Like many other sea creatures, the bottle-nosed dolphin communicates and locates its prey through sound. When approaching an object, the dolphin sends out rapid clicks that bounce off the object. The dolphin then senses the returning echoes. It can interpret these echoes so well that it can even tell the difference between one steel ball and another one just a quarter inch larger.

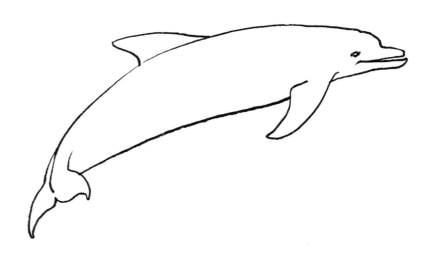

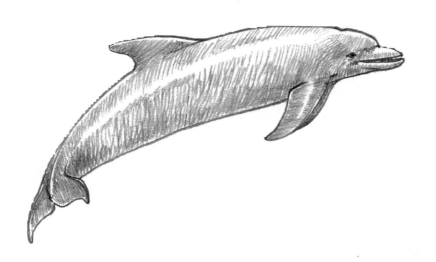

⑤ Finish your dolphin by shading its body and fins using smooth, even strokes. Leave a white streak along the upper side of the body to make it look wet. Darken the eye and the mouth. Sketch in darker tones around the tail fin, the far flipper, and around the face to complete your dolphin.

The bottle-nosed dolphin's jaws have 18 to 26 teeth on each jaw. These teeth are not for chewing, but for holding the fish it eats, which are swallowed whole.

The Great White Shark is the largest flesh-eating shark in the world. The average length of an adult

① Start your great white by sketching a long lima-bean shape for the body.

Sharks are different from other fish in that their skeletons are made of cartilage (the same material as on the tip of your nose) instead of bone. They also have rough plates called denticles for skin, while bony fish have scales.

② Add a wide oval for the shark's open mouth, with a lopsided triangle above it for the snout. Below the center of the body shape, draw a crescent shape for the shark's powerful tail fin. Notice that there's an extra point on the upper lobe of the tail.

The upper lobe of a shark's tail is actually the end of the animal's spine. The cartilage in the spine makes the tail especially strong, enabling the shark to swim very fast. In most sharks, the upper tail lobe is longer than the lower one, but in the great white the lobes are nearly equal in size.

③ Next draw the slender, curving "steering" fins on each side of the body. These are the pectoral fins. Be sure to add the small, backswept tip of the dorsal fin on the great white's back.

The pectoral fins, which are the fins closest to the shark's head, help the animal turn and steer quickly as it cuts through the water in pursuit of its prey.

MORE SCIENCE: Experts believe that when a great white attacks a human (which is rare), it is because the shark mistakes a swimmer for a seal or sea lion.

great white shark is 15 feet—longer than an automobile! Although it will occasionally eat seals and sea lions, the fearsome great white lives mostly on fish.

④ Now sketch two curved lines inside the mouth oval. These lines will help guide you in drawing the shark's jagged-edged teeth. Draw two more lines to connect the body to the tail fin. Then add the two small pelvic fins on the shark's underbelly as shown.

The teeth of the great white are very dangerous. Their serrated edges enable the shark to easily bite and tear off chunks of flesh that the shark then swallows whole.

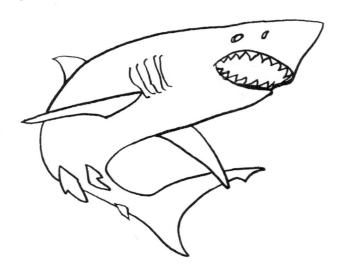

⑤ Pencil in the shark's eye, nostril, five gill slits, and its teeth. Draw in the small, triangular anal fin under the tail. Smooth the connections between the body, snout, and lower jaw as shown. Then erase unnecessary lines around the head, tail, and fins.

The eyes of the great white have a special lid called a nictitating membrane. As the shark attacks prey, this membrane slides across the eye to protect it from the sharp teeth and claws of the struggling prey.

⑥ Color in the eye, nostril, and the inside of the shark's mouth, and draw creases and light shading under the snout. Then, with straight, dark strokes, shade the dorsal and pectoral fins. Leave a thin white area on each front edge of these fins, and along the top of the shark's snout and upper back. Next use curved cross-hatching strokes to darken the upper body and lower tail.

When the great white's teeth break off, new ones erupt to replace them. Therefore, this deadly shark always has about 13 teeth on its upper jaw and 11 or 12 teeth on its lower jaw.

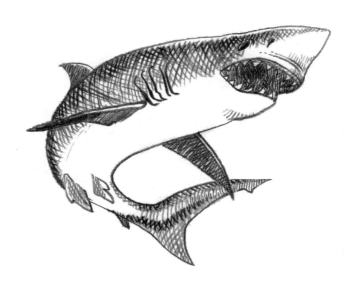

DRAWING TIP: The skin of sharks is as rough as coarse sandpaper. If you have a piece of sandpaper, try copying its texture on your drawing by using a stippling technique (see page 6).

The Scalloped Hammerhead Shark

① Your hammerhead shark begins with a long, curved oval for the body.

The scalloped hammerhead is a large shark. Adults range in length from 9 to 12 feet, about the length of a compact car. They feed on other sharks, crabs, bony fish, and stingrays.

② Add a crosspiece shape for the head and a rounded triangle for the tail.

Despite its awkwardly shaped head, this hammerhead is very speedy, and larger hammerheads have been known to swim through ocean waters at 17 to 22 miles per hour. You can tell that it is a fast-swimming fish by the crescent shape of the tail.

③ Next draw two small ovals on either side of the hammerhead's head. Then add a triangle for the dorsal fin and a fat triangle on the end of the tail to outline the tail fin.

Scientists believe that the location of the hammerhead's eyes, which are at the extreme ends of its broad crosspiece, may help the shark in tracking prey and maneuvering through the water.

MORE SCIENCE: Because the scalloped hammerhead is considered dangerous to divers and swimmers, fishermen hunt these sharks and sell their skin to make leather and their meat to make fish meal.

is one of the more unusually shaped fish in the sea. It is only one of nine hammerhead species (whose heads range from shovel and double-headed axe shapes to boomerang shapes). Even with its funny, cartoonlike head, the scalloped hammerhead shark is large, fast, and aggressive.

④ Now add a wiggly, V-shaped line inside the wide tail-fin shape. Then sketch in six triangular fins as shown.

The hammerhead shark roamed the seas long before humans appeared on Earth. Fossilized shark teeth show that this kind of shark, or a fish very similar to it, existed 100 million years ago—during the time of the dinosaurs!

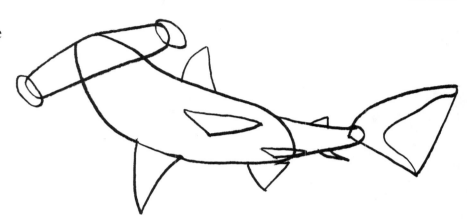

⑤ Indicate the shark's small eyes, the two little bumps in the center of its head, and the downturned mouth. Erase all unnecessary lines, and draw lines along the leading edges of some of the fins as shown to indicate their thickness.

The nostrils, located near the hammerhead's eyes, are not used for breathing but for smelling. Hammerheads, like other sharks, can smell blood in the water from miles away. They follow the smell to its source, which is often a wounded animal and therefore an easy meal.

⑥ Finish your hammerhead shark by using stipple texture. The hammerhead's skin is dark on the upper part of the body and pale on the underside. Also fill in the eyes, and darken the inside of the mouth, leaving a few small white spots along the top for the teeth. Don't forget to add five thin gill slits, so your hammerhead can breathe!

Found in temperate and tropical seas throughout the world, the scalloped hammerhead shark hunts in shallow coastal waters. While many shark types hunt alone, this hammerhead has been seen in schools of up to a hundred.

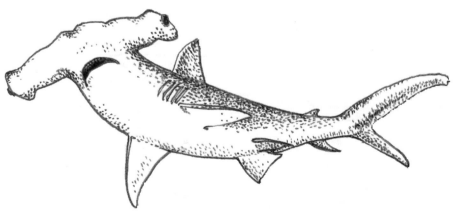

DRAWING TIP: To make this shark (or any animal you draw) more three-dimensional looking, experiment with the stipple texture. Draw the dots larger, darker, or closer together, and notice what happens to the look of your drawing.

The Starfish is a colorful animal that lives along the ocean floor, and it has neither a head nor a brain. Since the starfish cannot

① You are seeing this starfish from one side, not from directly above. Start by sketching the five-sided pentagon shape exactly as shown.

Starfish have five or more arms that radiate from a disklike body. When you lift a starfish out of the water, its muscles tense, and it feels stiff to the touch. But, underwater, the starfish's body and arms are quite flexible.

② Next draw an oval just to the right of the center of the pentagon. The starfish's arms will be drawn around this oval.

Some starfish eat plants, and others eat coral. The majority prey on bivalves, such as clams, oysters, and scallops, and occasionally on other starfish.

③ Now add the five slender, curving arms of the star that stem from the center oval to the corners of the pentagon.

A starfish moves on its tube feet, which are rows of flexible, muscular tubes underneath each arm. In some species, these tubes have suckers that can grip tightly. When feeding, the starfish uses its suckers to latch onto and force open the shells of clams and other shellfish.

MORE SCIENCE: Starfish vary in size, proportion, and color. The largest can have arms 26 inches long. And some starfish have as many as 40 arms!

see, it senses its food by detecting chemical changes in the water. It then uses its flexible tube feet to move toward its prey.

④ Draw additional lines around the edges of the arms to show how thick the starfish is.

Bumps on the starfish's top surface act as gills. They are used to obtain oxygen underwater.

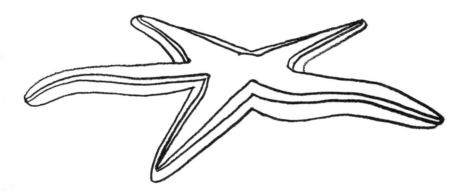

⑤ Sketch one more set of lines between the lines you drew in steps 3 and 4. Now erase the center oval and the pentagon.

Did you know that if you flip a starfish over, it can turn itself right side up in a matter of minutes, or even seconds? It uses its strong tube feet and its flexible arms to right itself.

⑥ Now your starfish is almost complete. Draw small bumps on top of the starfish and a hump in the middle. Use short, straight lines to fill in the borders of each arm as shown. This type of starfish has a row of pointy thorns around each arm. Draw these in. Don't forget to add the slender, curving tube feet beneath each arm!

A starfish cannot run or swim away quickly when a predator such as a large sea snail attacks. But it can reject, or break off, an arm that an attacker is biting, and thereby escape. The starfish doesn't stay crippled, though. It grows new arms to replace the broken ones!

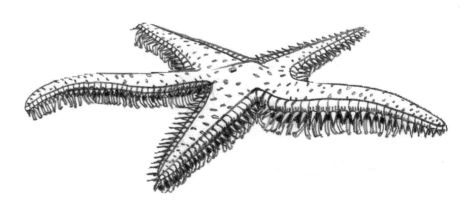

15

The Deep-Sea Anglerfish may look like a monster, but it is not dangerous to humans. This bizarre fish lives between

① To begin, sketch a slightly flattened circle for the anglerfish's body. Add a dome shape overlapping the lower part of the body for the animal's mouth.

The sacklike body of this fish makes it possible for the anglerfish to swallow prey as large as itself—and to swallow it whole! This fish can survive on relatively few meals. That's fortunate, because the deep waters in which the fish lives are sparsely populated.

② Add a rounded triangle on the right side of the body for the tapered tail and a smaller dome shape inside the mouth. Then draw the odd stalk and bulb sticking out of the anglerfish's head.

The anglerfish's long, flexible stalk of flesh is called the esca. The anglerfish uses the bulb at the end of the esca to lure prey. When a potential meal nears the bait, the anglerfish engulfs it in its wide jaws. Interestingly, only the females are equipped with this handy "fishing pole."

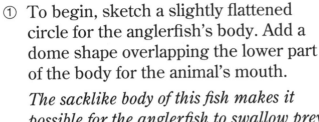

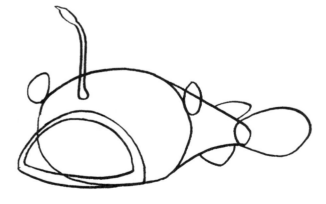

③ Next sketch in two small ovals and two triangular shapes for the fish's fins, as well as a pear shape for the tail fin.

The anglerfish's esca can flash yellow, purple, or other bright colors. The fish controls this colored light by pumping oxygenated blood to the esca and stimulating the bacteria inside the esca, causing it to glow.

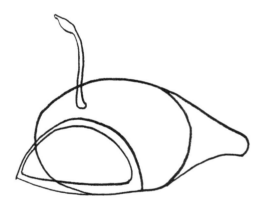

MORE SCIENCE: The female anglerfish is small, but the male is even smaller. He actually attaches himself to the female when both are young. When the female is grown and ready to spawn, the male is there to fertilize the eggs; otherwise, he lives off the female as a parasite.

3,000 and 12,000 feet under the sea, where its environment is totally dark and near freezing! The largest anglerfish ever seen was only 8 inches long, and most are no bigger than a man's fist.

④ Now add thick bases to the ovals for the pectoral fins. Draw the horns on the fish's head and cheek, and don't forget to add the tongue and the peculiar, rootlike beard.

The angler's "fishing rod" is actually a modified dorsal fin that has evolved over the years to protrude from the front of the fish's head. An anglerfish can actually wiggle her bait!

⑤ Next draw the creepy, fanglike teeth that curve slightly toward the inside of this creature's mouth. Note that the fangs are different sizes. Add the eyes, and begin detailing the webbed edges of the fins. Erase all the unneeded and overlapping lines around the head, body, and tail.

After young anglerfish hatch, they live near the ocean's surface, and their eyes grow normally. However, as the fish mature, they sink to their dark, deep-sea habitat, and their eyes, no longer needed, stop growing. In fact, in some species, the eyes almost disappear.

⑥ To finish your anglerfish, shade the mouth with dark hatching. Draw nostrils on either side of the stalk, and darken the centers of the eyes and the fleshy bait. Then draw ribs on the fins, and shade the webbing. Add heavy dots and tiny ovals to suggest bumpy skin, and add light hatching around the head and beard.

The angler's skin is warty, scaleless, and nearly black. However, in addition to the glowing bait, some species of anglerfish can make their fleshy beards glow at the tips, making the fish visible to others.

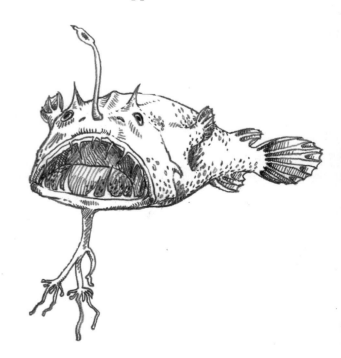

The Blue Whale is probably the largest animal that has ever lived, even including the dinosaurs! At a maximum

① To start your blue whale, draw a long oval. Make the oval narrower at the left end, where the mouth will be.

In spite of its huge body, the blue whale is a fast and graceful swimmer. When it is alarmed, the whale can plow through the water at almost 30 miles per hour by moving its strong tail up and down.

② Next draw a blunt, upward-curving shape for the tail and a curved V shape for the whale's open mouth.

Instead of teeth, the blue whale has baleen, which are waferlike bony plates. To feed, this gentle giant sucks in huge quantities of water—together with the tiny shrimplike animals swimming in it. It then squirts out the water through the baleen plates, which catch the animals so the whale can swallow them whole.

③ Now draw the broad triangle that outlines the blue whale's tail flukes. Add the small dorsal fin on its back and a paddlelike flipper in the middle of its body.

The blue whale's flippers seem small in relation to its size, but on a normal adult whale each flipper is about 10 feet long and could cover two average-sized fifth graders lying head to toe!

MORE SCIENCE: The baby blue whale is 24 feet long when it is born, and it grows fast on its mother's milk, gaining 200 pounds a day!

length of 100 feet each, three blue whales placed end to end would cover the length of a football field. One of these gigantic mammals weighs as much as 30 elephants.

④ Divide the tail into two flukes, then add the eye, the inner edge of the lower jaw, and the edge of the baleen below the upper jaw. Sketch the grooves on the blue whale's underside that allow its throat to expand. Now erase all unnecessary lines. Notice the slight dip on the head above the eye. That is where the whale's nostril is located.

This amazing air-breathing mammal needs to come to the surface for air. When the whale exhales, a narrow plume of water droplets, called a "blow," shoots out of the whale's blowhole. Sometimes the plume of water is propelled three stories high!

⑤ Finish your magnificent blue whale by darkening the eye and the inside of the mouth. Draw vertical lines to show the spaces between the baleen plates. Then shade the body, leaving light patches and adding darker spots as shown. Add special shading underneath your blue whale's lower jaw and side flipper.

The blue whale's only significant enemy is man. Hunted almost to extinction, this huge creature of the sea is considered an endangered species and is protected by law worldwide.

The Sperm Whale is the champion diver among air-breathing sea mammals. This remarkable animal has been

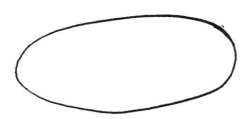

① For the body of your sperm whale, start with an oval that's tipped up slightly at the right end.

The sperm whale is the largest of the toothed whales (other whales, such as the huge blue whale, have baleen instead of teeth). The male can weigh more than 75 tons and grow up to 60 feet long—the height of a five-story building!

② Now draw the tail so that it curves up and tapers to a point. Add a smaller, overlapping oval for the whale's head.

What looks like the sperm whale's tall forehead is actually an oversized nose! Besides air passages needed for breathing, the bulge contains spermaceti (sper-muh-SEET-ee) wax. Scientists believe that this natural wax, warmed by the whale's blood, acts like a balloon to help lift the whale from a deep dive. When the wax is cooled, it becomes solid and denser to help the whale submerge again.

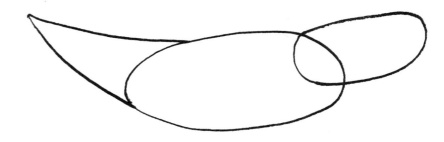

③ Next sketch the broad triangular outline of the tail flukes, a narrow oval shape for the lower jaw, and a small oval shape for the flipper.

The bones in the sperm whale's flippers are similar to the leg, ankle, and foot bones of land-dwelling animals, indicating that the ancestors of this creature also lived on land. To get an idea of the size of this grand animal, look at the flipper you just drew. It may look small in this drawing, but on a real sperm whale, it is about 6 feet long, the height of an average adult male!

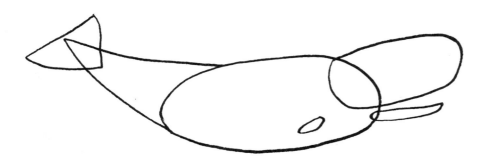

MORE SCIENCE: While sperm whales feed on sharks, octopus, shrimp, crabs, and other fish, their favorite food (and biggest enemy) is the squid. In fact, sperm whales often bear circular scars on their jaws and head from the sharp-edged sucking disks of a giant squid that was fighting its predator.

known to dive down almost a mile (4,000 feet) to hunt for food, and it can hold its breath for more than an hour!

④ After you sketch in the two separate sections of the tail flukes, add the eye, the narrow base of the flipper, and the long oval upper jaw.

Sperm whales form close social groups. Nursing sperm whale calves stay with their mothers for at least a year and often longer, even after they have learned to hunt for their own food. Groups of whales have been found together with calves that are at least 10 years old.

⑤ Indicate the ridges along the whale's lower back, making them smaller as they near the tail. Add narrow lines to the flipper and right fluke to show their thickness, and sketch in the heavy, cone-shaped teeth on the lower jaw. Smooth the joints between the body sections, and erase any extra lines.

The sperm whale's heavy teeth probably help the creature to hold large prey, but they aren't used for chewing. In fact, because sperm whales usually swallow their food whole, they don't appear to need teeth to survive. Healthy, well-fed specimens have even been found without teeth.

⑥ Finish your sperm whale by adding thick hatching lines to suggest thick skin. Darken the eye and the inside of the mouth. To create a three-dimensional effect, add more hatching lines along the sperm whale's underside, and leave a thin white rim around the mouth. Draw heavy irregular lines to show scratches and scars on the thick skin. You can emphasize these marks by adding narrow white lines around them to make them look like deep cuts.

The sperm whale's skin is almost black. The skin's texture is rippled on young whales and becomes deeply wrinkled and scarred with age. At 14 inches thick, the skin of the sperm whale is the thickest of any member of the animal kingdom.

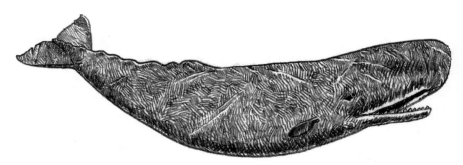

The Giant Squid

has been made famous in numerous tales and legends of sea monsters. It is the largest known sea creature that doesn't have a backbone. Like

① The main part of your squid starts with the mantle, a long, flamelike shape with a tapered tip.

Never seen alive by humans, the giant squid dwells as deep as 5,000 feet in the ocean. However, individuals have been known to surface, perhaps in pursuit of prey. Based on the size of its tentacles, the weight of the largest of these creatures has been estimated at 6,000 pounds!

② Now draw an egg shape next to the mantle. This will be a guide when you draw the creature's flowing arms. A small, curved-edge arrowhead shape at the tip of the mantle outlines the fins. Add a line from the tip of the arrowhead to the base to show where the right fin attaches to the mantle.

The squid is a member of a group of animals called cephalopods *(SEF-uh-luh-podz), a Greek name meaning "head and foot." It is related to the snail; however, unlike the snail, the squid's narrow shell is inside the mantle rather than outside of it. The shell protects the squid's internal organs.*

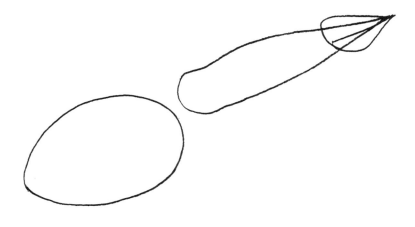

③ Begin the squid's enormous eyes by drawing a circle and a smaller oval. The line you sketch in above the eyes will be the edge of the mantle.

The squid has the largest eyes in the animal kingdom—the eyes of some specimens have been measured at 15 inches across! Its eyes are also very advanced for an animal without a backbone. In fact, squids can probably see more clearly than humans can, though they cannot change focus as well.

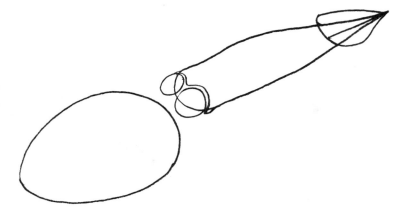

MORE SCIENCE: In the ocean depths where it lives, the giant squid actually glows in the dark. Special organs in the squid cause rings and dots of colored light to shine around the creature's eyes and inside its arms.

its relative the octopus, the squid has eight arms, but it also has two very long tentacles for grasping prey. Specimens have been measured at 60 feet long from the top of the head to the tips of the tentacles.

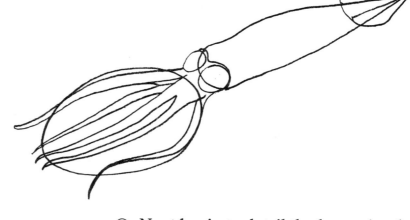

④ Now draw five slender, tapering arms, which grow in a ring around the squid's mouth. The arms have suckers that face the center of the ring. This means that you will be drawing suckers on the arms farthest from you, and the backs of the arms closest to you.

The squid's suckers are raised on short stalks and have hard, sharp edges that cut into the prey's skin. Some squids have suckers ringed with claws that can be extended at will like a cat's claws.

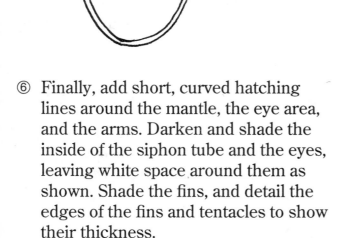

⑤ Next begin to detail the large circular eyes, the groove down the center of the mantle, the two long tentacles (notice the broad pads at the ends), and the short siphon tube below the eye. Add the remaining three legs. Where shown, draw suckers along the inside of each arm and on the pads of the tentacles. Erase any unneeded lines.

The squid moves by jet propulsion, taking water into its mantle cavity, then forcing it out through its wide siphon tube. While the squid's usual direction of movement is backward (mantle first), it can move forward by changing the direction of this tube.

⑥ Finally, add short, curved hatching lines around the mantle, the eye area, and the arms. Darken and shade the inside of the siphon tube and the eyes, leaving white space around them as shown. Shade the fins, and detail the edges of the fins and tentacles to show their thickness.

The squid's arms form a ring around the animal's mouth. Hidden by double lips, the mouth has sharp, parrotlike jaws that are powerful enough to crack fish skulls and the shells of crabs and other crustaceans.

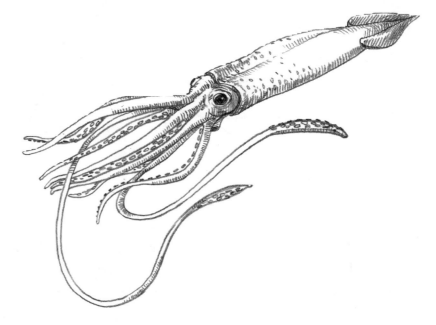

The Coelacanth

was once believed to be extinct, since a fossil of one was found dating from the era of the dinosaurs. But in 1938, scientists were astounded when a live

① Begin your coelacanth with an oval that's narrow at the left end and has a slight hump on top.

The steel-blue coelacanth can be 6 feet long and weigh 150 pounds. Since the first coelacanth was found, more than a hundred have been caught and sent to museums around the world for study.

② To make the head, draw an overlapping triangle with curved corners. Add a separate rounded diamond shape for the tail.

An unusual feature of the coelacanth is its triple tail. The fish has an extra central tail fin that is used both for balancing and for keeping the fish upright in the water.

③ Next sketch ovals for the fins. Notice that the fins point backward, away from the head. The longest oval will serve as the pectoral fin, the fin that is used for steering and is closest to the coelacanth's head.

The coelacanth is one of the few living fish that has lobed fins at the ends of bony, muscular limbs. Fossil records show that an extinct group of fish related to the coelacanth may have evolved over millions of years into today's amphibians.

MORE SCIENCE: Because no coelacanth has survived in captivity so far, information about the creature is still sparse. But the fish is of great interest because its ancient relative is thought to be the immediate ancestor of the first backboned creature to leave the ocean and live on land.

coelacanth (SEE-luh-kanth) was caught off the coast of South Africa. This unexpected link to prehistoric fish reminds us of how slowly some creatures evolve—and how the seas may hold mysteries yet to be discovered!

④ Now attach the coelacanth's body to the tail, leaving a curved edge inside the diamond shape that will form the base of the tail fin. Draw fingerlike stumps beneath all the other fins as shown, except for the dorsal fin in the middle of the fish's back. Don't forget to outline the mouth and connect the base of the head with the stump on the pectoral fin.

The broad jaws of the coelacanth are lined with sharp teeth for catching smaller fish.

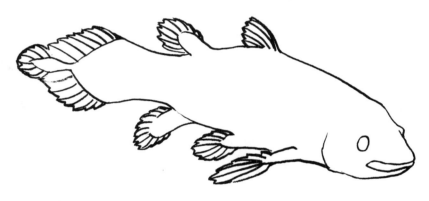

⑤ You are now ready to create the bony spines in the coelacanth's fins by drawing lines that fan out from the tail and the stumpy limbs. You can go outside the ovals if you need to. Add the little central tail and its fin. Now draw the eye, the ridge of the other eye, and the edge of the gill cover, which extends about halfway up from the base of the head. Smooth the connections between the body, head, and tail, and erase overlapping construction lines.

With their sharp, prickly spines, the large and bony scales of the coelacanth cover the body and extend onto the stumpy limbs.

⑥ Your coelacanth is almost done. Draw the tough, overlapping scales, curving them to follow the roundness of the fish's body and tail. Around the edges of the body and in the limbs, sketch in short, dark hatching. Don't forget to add shading around the fins, especially on those underneath the coelacanth to give a three-dimensional effect. Finally, darken the eye and the inside of the mouth, and add highlights around the face as needed.

The coelacanth has another unusual feature: a hinged skull. When most fish and animals (including humans) open their jaws, only the lower jaw moves. The coelacanth can also raise its upper jaw by tipping its head back along its spine. This allows the fish to swallow large prey.

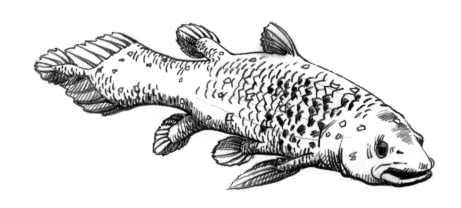

The Seahorse might look as though it doesn't belong in the ocean, but this graceful creature is actually classified as a spiny-

① Start your seahorse by drawing a flamelike shape with a circle attached at the top. This will be the body of the seahorse, as well as the main part of its head.

Like the octopus, the seahorse has the ability to change its color to match its surroundings, and it uses this ability to protect itself from predators. A slow swimmer, the seahorse is often found anchoring itself among plants in the reefs where it lives.

② Next add a curved line that starts at the head and ends in a spiral for the tail. Draw in the long, slender snout and the fan-shaped dorsal fin as well.

The only fish that has a tail flexible enough to wrap around coral or undersea plants, the seahorse can stay anchored against the movement of currents and surge of waves.

③ Now draw the shapes for your seahorse's curved forehead and crest. Finish the shape of the tail by sketching a curved line from the dorsal fin to the spiral as shown.

The dorsal fin keeps the seahorse in a vertical position. Even though it moves briskly for its size, the average seahorse takes a full five minutes to swim the length of a bathtub!

MORE SCIENCE: Believe it or not, the male seahorse has a pouch on his stomach! It is here that the female lays her eggs. After she deposits the eggs, the male incubates them, squeezes the young out when they hatch, then flushes out his pouch to prepare for the next batch of eggs.

finned fish. Measuring only a foot at its largest and 2 inches at its smallest, the tiny seahorse lives in all but the coldest waters.

④ Add an oval for the mouth, which is located on the tip of the snout, and a circle for the eye socket. Draw the outline of the pectoral fin (on the right side of the head), then, to the left of that, add the edge of the gill cover (the line that completes the circle of the head). Sketch in a line to connect the abdomen and tail, and add the lower edge of the head, including the small bump.

The seahorse uses the pectoral fins behind its eyes to steer through the water in search of food. With its tubelike mouth, the creature is able to poke into undersea grasses and suck in tiny crustaceans to eat.

⑤ Now pencil in the scalloped outline of your seahorse, making the ridges smaller around the head and tail. Add the round eye, the mouth, and the jagged ridges inside the outline that run the length of the body and tail. Erase the unnecessary lines, then begin to add detail to the fins.

The bulging eyes of the seahorse move independently of each other, allowing the animal to see in more than one direction at the same time.

⑥ Finish your delicate seahorse by darkening its eye and drawing several lines on the dorsal and pectoral fins to show texture. The seahorse's body is a collection of flat, hard plates connected with little knobs. Straight, dark hatching lines can bring out the plates, but be sure to leave white spaces to show the ridges in between the plates. Shade the lower sides of the knobs along the creature's back and side to make them stand out and look round.

For protection, the seahorse has not only a skeleton inside its body, but also an armored covering made of a slick, bony material.

DRAWING TIP: Notice how the hatching gradually gets darker as you get closer to the tail.

The Sailfish is a relative of the tuna and is admired as one of the strongest and fastest-swimming fish in the world. Its huge

① Your magnificent sailfish begins with a slightly curved carrot shape.

The sailfish lives on fish, squid, and crustaceans, and it thrives in temperate and tropical waters worldwide.

② Next add a broad fan shape for the tail fin and a long, tapered teardrop shape for the head and upper jaw.

People used to think that the long, pointed upper jaw of the sailfish was used to spear or slash prey as the sailfish sped through schools of fish. More recent studies show that the purpose of the polelike bill is to cut a smooth path through the water, helping the fish to swim at maximum speed.

③ Now sketch in the huge dorsal fin that gives the sailfish its name, and add the lower fins and the lower jaw. To define the edge of the tail fin, draw in a wide U shape. Be sure to add the two tiny bumps in the center of the curved tail. Also sketch in two small ovals at the base of the tail (these are sharp bony plates that fish in the tuna group often have to help them steer). *To date, the largest sailfish ever weighed a hefty 275 pounds.*

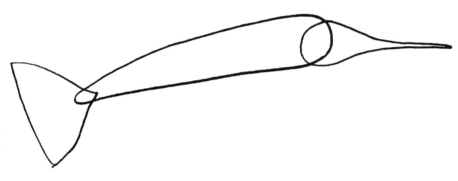

MORE SCIENCE: Even though a female sailfish normally produces several million eggs each year, only a few of them ever reach maturity. Upon hatching, a young sailfish has teeth, a very long, low dorsal fin, and top and bottom jaws that are equal in size. As the hatchling nears 2 inches in length, it starts to develop a long bill and a sail-like dorsal fin, resembling a small adult sailfish.

sail also makes it one of the most unusual fish to swim the ocean.

④ Add two small fins, one above the tail and one below, followed by the round eye and the two long chin "whiskers."

The coloring of the sailfish—dark blue-black on its back and white on its underbelly—helps to camouflage this large fish. When it is viewed from above, the sailfish blends in with the darkness of the deep water. When viewed from below, its pale belly blends in with the shallow, sunlit water.

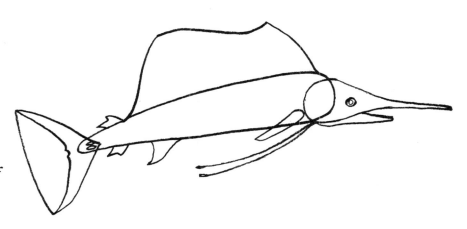

⑤ To create a sense of thickness, add lines along the top and bottom of the tail fin, the front edge of the pectoral fin, and the front of the dorsal fin. Don't forget to draw the gill slits, the ridge of the fish's left eye, and the inside of the mouth. Begin to shade your sailfish with dark lines underneath the lower jaw, and darken the chin whiskers as shown. Erase any extra lines.

The "crescent-moon" tail of the sailfish, like that of its relatives (which include the tuna and the swordfish), is designed to provide short bursts of high speed as well as fast long-distance swimming.

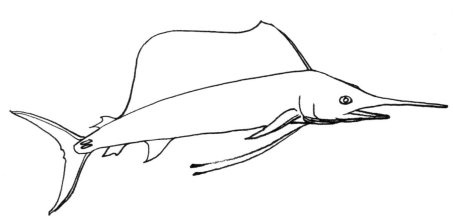

⑥ Put the finishing touches on your sailfish by detailing the rays within the fins and tail. Notice how the edge of the large sail is slightly scalloped. Add shading along the upper part of the body, the lower half of the beak, and around the lower jaw. To give your sailfish even more detail, add a few rows of dots on its dorsal fin, as well as on its body. Last, emphasize its eye.

Can you imagine a fish that swims through the water as fast as a car travels on the freeway? The speedy sailfish has been clocked for short distances at 68 miles per hour!

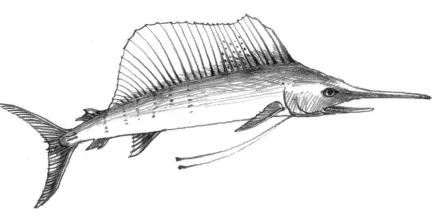

The Sea Otter is the smallest of the seagoing mammals. This fascinating marine cousin of the weasel is

① To begin, draw an oval for the sea otter's chubby body. The oval should be slightly broader at the higher end for the head.

The male sea otter is larger than the female. It usually weighs between 30 and 80 pounds and grows to about 5 feet long.

② Add a slightly flattened circle for your otter's head. For its tail, draw a wavy, tapered shape that's just a little shorter than the body oval.

The playful sea otter may be clumsy on land, but in water it is a graceful swimmer, moving itself forward by sweeping its broad tail from side to side and kicking its webbed hind feet.

③ Next add shapes for the forelegs and two ovals for the hind feet. Sketch an upright oval for the otter's muzzle.

When it's not diving for sea urchins, fish, and shellfish to eat, the otter often floats on its back among the seaweed, paddling with its hind feet. It uses a flat stone as a tool to open the shells of crabs and clams. Balancing the stone on its chest, the otter pounds the shellfish against it.

MORE SCIENCE: During the 17th and 18th centuries, so many otters were killed for their fur that, by the early 1900s, the animals were thought to be extinct. However, a few groups survived, and now, with laws protecting them, sea otters are returning to their old habitats.

the only sea mammal known to use tools.

④ Connect the base of the tail to the otter's hind foot as shown, then begin to shape its legs. Follow that by adding two chubby, egg-shaped cheeks.

The otter can normally dive to 75 or 80 feet. It can hold its breath for about a minute. When in danger, however, otters can stay underwater for up to four minutes.

⑤ Draw the eyes, nose, and claws, and smooth the connection between the head, body, and other limbs. Begin to add detail to your animal's two webbed hind feet. Erase any extra lines.

The female sea otter gives birth to a cub every other year. The young, about 20 inches long and 3 to 5 pounds at birth, is cared for by its mother until it can find food on its own. In the wild, sea otters are believed to live as long as 20 years.

⑥ Your playful otter is nearly complete. Use hatching to represent the thick fur, which is heavy on its upper body. Darken the nose, eyes, and mouth. Shade the lower section of your otter's tail, as well as its hind feet and back (which are all underwater). Add an oyster on the animal's chest, and draw watery rings that wrap around your otter. Now your otter can float comfortably while it dines!

The otter's brown or black fur is extremely soft and is six times as thick as a cat's fur. It is so thick that air bubbles trapped in the fur near the skin actually help keep the skin dry.

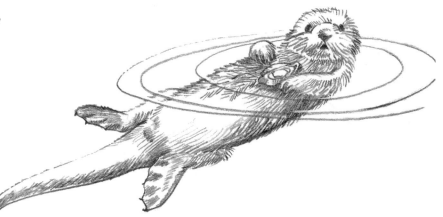

The Killer Whale

is the largest and fastest member of the dolphin family (all dolphins are members of the whale family!). This intelligent marine mammal feeds

① Start your killer whale by drawing a fat banana shape for the body, narrowing it where the tail will be.

The male killer whale can grow to 33 feet. That's as long as two large automobiles placed end to end. It can weigh anywhere from 10,000 to 18,000 pounds.

② Now add an oval for the head and a half oval for the tail flukes.

A killer whale usually stays with its family, called a pod, all its life. The family can migrate several hundred miles from season to season, and all its members hunt together.

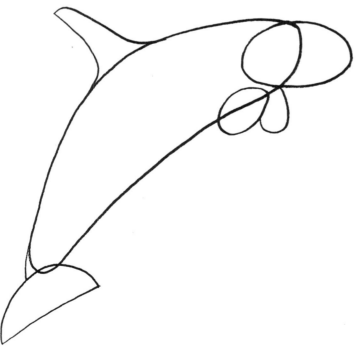

③ After you add shapes for the whale's dorsal fin and rounded flippers, begin to smooth the connection between the body and the tail.

With powerful up-and-down sweeps, the killer whale's tail can propel the creature through the water at high speeds of up to 35 miles per hour.

MORE SCIENCE: You can tell a killer whale is female by her backward-curving dorsal fin. The male's dorsal fin is straighter and longer (see illustration), standing as tall or slightly taller than the average man. These magnificent creatures have no natural enemies.

mostly on fish and squid, but it is called "killer" because at times it also hunts other marine mammals, such as seals and other dolphins and whales. However, it avoids humans.

④ Next detail the tail flukes, adding a notch between them as shown. Sketch in the eye, then add the white markings on its underside, around its lower jaw, and near this whale's eye. Open your killer whale's mouth by adding a narrow V shape as shown. Erase all unnecessary lines.

Like its dolphin relatives, the killer whale has a bulge in its forehead, called a melon. The thick liquid inside the melon enables the killer whale to feel sound vibrations in the water, including echoes of the animal's own clicks and whistles. The killer whale uses these vibrations to locate prey and to communicate with other killer whales.

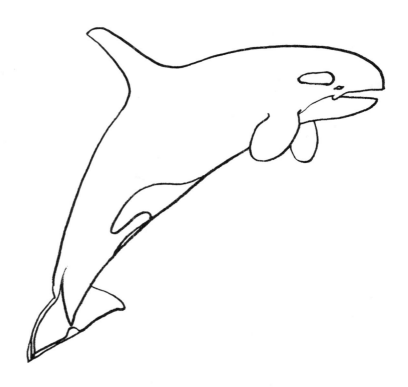

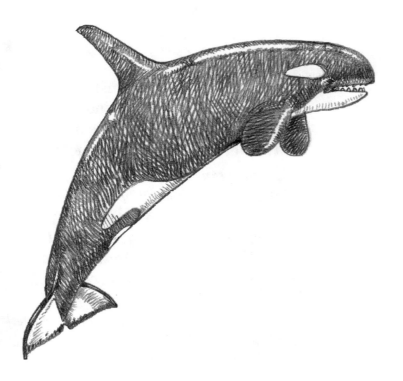

⑤ Leaving white streaks where shown, use curved cross-hatching lines to darken this sleek black-and-white animal. Color in the eye, and draw the small, cone-shaped teeth. Be sure to add light shading to the killer whale's white patchy areas to give your drawing a three-dimensional feel.

Like other dolphins, the killer whale's jaws are lined with cone-shaped teeth that are used for grasping prey.

DRAWING TIP: When using pencil, a good way to create white streaks is first to cover an area with hatching (or stippling, etc.), then to erase the pencil marks in long streaks. This technique will make the animals in your drawings look shiny and wet.

The American Lobster is actually a seagoing relative of insects and spiders! Just as with

① Start your lobster by drawing a shape that will be the head and the body. The pointed end will become the tip of the lobster's face.

The American lobster, also known as the Maine lobster, feeds on crabs, clams, mussels, starfish, sea urchins, and other lobsters. The largest lobster ever measured was 3 feet long and weighed 48 pounds. Since lobsters keep growing throughout their lives, size is a good indication of age.

② Now draw part of a crescent for the lobster's tail and two thick shapes for its forelegs, which will be connected to the giant claws.

The lobster uses its four back pairs of legs for walking on the seafloor. Its two clawed forelegs, called pincers, are used for defense and for holding and crushing the shells of prey.

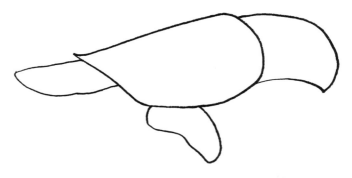

③ Draw in the base of the tail as a rounded shape. Draw a slender oval for what will become the small eating legs and two more ovals for the pincers.

Like other crustaceans (krus-TAY-shunz), lobsters develop a hard, jointed shell that protects them from predators and physical damage. The shell does not grow; instead, as the animal grows, it sheds its shell and grows a new, larger one in its place. When the lobster is young and growing at its fastest pace, each new shell is about one-fifth bigger than the last one.

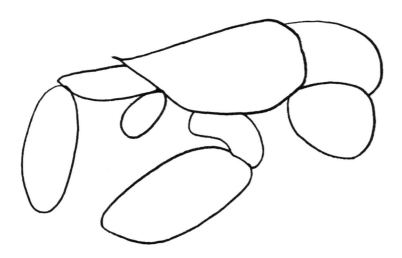

MORE SCIENCE: An efficient recycler, the lobster often consumes its own molted shell! Its body can use the ingredients in the old shell material to form a new shell.

many of these small land animals, the lobster's most obvious characteristic is its skeleton (called a shell), which is on the *outside* of its body.

④ Next add the claws' moveable "thumbs," the rounded lower section of the eating legs, the top halves of the curved walking legs, and the tiny swimmerets under the tail.

By flexing its strong, jointed tail, the lobster can move quickly, either forward or backward. It has keen eyesight, but it detects food by using both the sensing hairs along the lower edges of its shell and the four antennae at the front of its head.

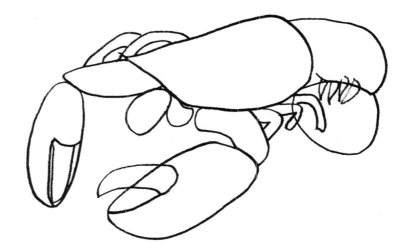

⑤ Now finish the joints on all the legs. Notice how the legs are very similar to those of insects. Sketch in the tail sections, the eye, the two small antennae, and the two large antennae. Begin to detail the two pincers and the tail.

Female lobsters can lay from 8,000 to 12,000 pinhead-sized eggs every year, but only 8 to 10 of the young that hatch ever live longer than six weeks. Slow growing, the lobster larvae take four years or more to reach just 1 pound.

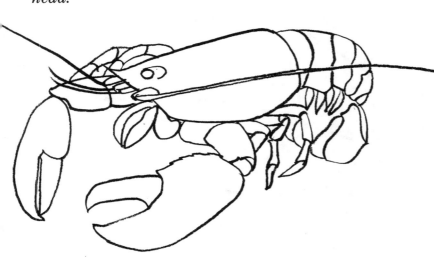

⑥ Put the final touches on your lobster by sketching jagged edges on its claws and a hairy fringe along its tail and legs. Darken the eye and the area around the eye, and use dark stipple to detail the shell. Don't forget to complete the large antennae by adding a curve to one and short vertical lines inside the other.

Live American lobsters are dark greenish-brown or black with an orange tinge. The familiar color of a cooked lobster appears only when the other colors of the shell are destroyed by the heat from cooking.

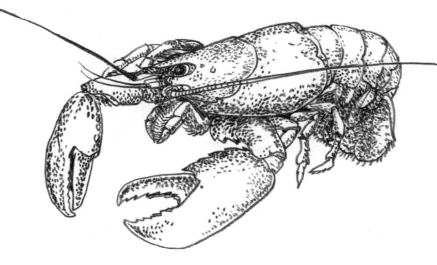

The Queen Conch is a large oceangoing snail that lives in the Atlantic Ocean off the coasts of Bermuda, the

① Start your conch (KONK) shell by drawing a pie-shaped wedge.

While the mature queen conch (also called the pink conch) averages 9 inches in length, it can be as much as 13 inches long from tip to tip.

② Next add a triangular shape on top of the wedge, making sure the triangle's sides don't extend to the outer edges of the wedge. Then overlap the wedge with a flat oval shape, which will serve as the shell's flared lip.

The queen conch's shell hides a snail that eats undersea plants. While it moves along the ocean floor by rippling and extending a flat muscular foot that comes out of the bottom of the shell, the snail's soft head and body are protected inside.

③ Now draw a scalloped line along the inside of the pie wedge and oval shape as shown. Also fill in the triangle with several rows of scalloped lines.

This snail, like other mollusks, has no teeth or jaws, but it scrapes up little bits of food by running a rough-toothed muscular strip called a radula over a plant or rock.

MORE SCIENCE: People collect the queen conch not only for its tasty flesh, but also for its large, beautiful shell, which is sometimes carved into jewelry. A special prize from the queen conch is the pink pearls it can make, some as large as grapes.

Caribbean Islands, and Florida. Its beautiful pink-lined shells were some of the first natural treasures explorers took home to Europe during the time of Columbus.

④ Erase all the unneeded lines. You should now have the outline of the conch's shell. Add a small hole with two eye stalks coming out as shown. Draw the front and tail of its soft body peeking out at each end.

The snail has to see where it is going, so the shell of the queen conch has a special notch at the forward end of its opening. The snail pokes its eye stalks through this, leaving its head protected inside the shell.

⑤ Finish this beautiful shell with hatching lines. Shade the points on the shell with short, dark hatching lines, giving them a rounded look. Finally, add a light line around the lower edge of the shell, and draw faint lines down and around the cone part of the shell. These are the growth lines that show the age of the shell, like rings in a tree.

The hard shells of snails, such as the queen conch, are made of calcium, the same material found in the bones of land animals. Secreted by glandlike cells in the snail's soft body, small amounts of calcium are gradually added at the shell's lip. Ridges on the outside of the shell show where growth stopped for a time, such as when less food was available or when the water was too cold.

The Compass Jellyfish is a relative of starfish, sea anemones, and corals, and like

① The first shape is the widest part of the jellyfish's bell, or body, seen from one side. Draw it as an oval, flattened slightly at the narrow ends.

The compass jellyfish can reach 49 feet in length, including its tentacles, and its sting is painful and can even be dangerous to humans. The jellyfish uses its stinging tentacles to stun the small fish it eats.

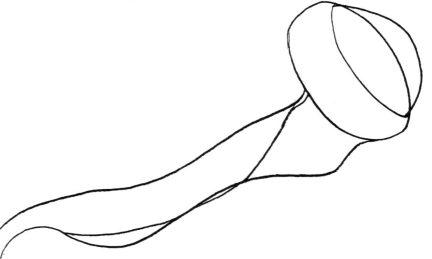

② Create the crown of your jellyfish by overlapping a mushroom-cap shape with the bell oval. For the creature's three main tentacles, draw three long, curving lines.

The flowerlike compass jellyfish has tentacles arranged radially around the creature's mouth, which is on the underside of its bell.

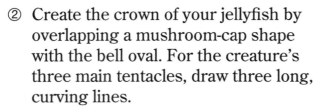

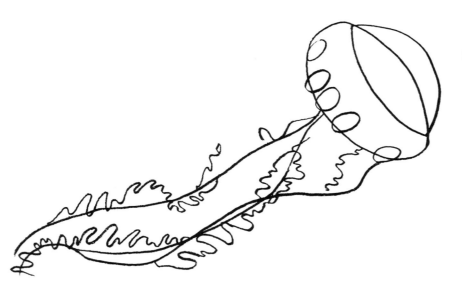

③ Now sketch five ovals along the edge of the jellyfish's bell, and draw wiggly lines that weave in and out around the long tentacles.

As the jellyfish drifts, the movements of small fish activate the stinging cells on its tentacles. Each cell shoots out a whiplike strand equipped with barbs and venom to capture the fish for food.

them, it has no backbone or head. Unlike its cousins, however, the jellyfish is a swimmer of the open ocean, and it can be much larger.

④ Draw curving lines to connect the wiggly lines you drew in step 3 to the tentacles. These wiggly lines are the edges of ruffles that are attached to the main tentacles. Then add the rest of the slender, tapering tentacles, which are a bit shorter than the main ones. Erase the extra lines, especially around the bell of the jellyfish.

Using muscles to open and close its bell, the jellyfish swims gracefully up to the ocean's surface at night when its prey usually gather, and then it sinks during the day.

⑤ Complete your jellyfish by delicately shading the bell with the side of your pencil lead. Make the shading paler around the top edges and darker in the center for a rounded, three-dimensional effect. Detail the ridges on the top of the bell as shown, and darken the five oval shapes (they are usually dark purple on the live animal). Thicken the tentacles, then shade in the ruffles, making them darker toward the tentacles and lighter toward the floating edges.

When a new jellyfish begins life as a larva, it sinks to the sea bottom, where it attaches upside down to drifting single-celled animals. It feeds on these animals until it is large enough to float free. Then it turns bell-side down and becomes a swimming predator.

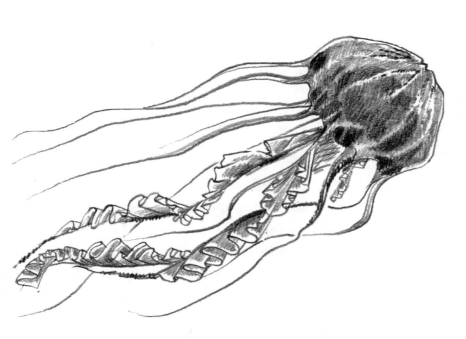

The Giant Manta Ray is a relative of the sharks and is sometimes called a devilfish because

① To start your manta ray, draw a broad oval for the body. This view of the manta ray shows the underside of its body.

The manta is the largest of the rays. The biggest specimen ever found measured more than 20 feet from wing tip to wing tip and weighed as much as an elephant! This kite-shaped fish lives in both the Atlantic and Pacific oceans.

② Next add a wide pie-shaped wedge as a guide for the ray's head and horns. Don't forget to sketch a stub for the tail base.

Unlike the pointed teeth of most of its shark relatives, the manta's teeth are flattened for grinding its small prey and are located at the back of its mouth.

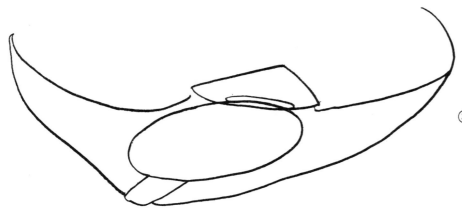

③ Now indicate the ray's upswept, pointed wings, as well as a long, narrow shape for the mouth.

The so-called wings that flap to move the manta smoothly through the water are actually enlarged pectoral fins (the steering fins that, on most fish, are right behind the gill openings).

MORE SCIENCE: The manta ray is ovoviviparous (oh-voh-vy-VIP-uh-rus), which means that its eggs hatch while they are still in the mother's body. The newborns, which can be more than 4 feet wide and weigh 25 pounds, are sometimes born during a female's leap from the water. The newborn mantas hit the water swimming!

of its ominous-looking "horns." It is large and does indeed look fearsome, but it tends to avoid humans, preferring to feed on small fish, shrimp, and plankton.

④ Continue by adding the sharp tail, the split in the tail base, the top side of the wing on the right, the small black eyes and their grooves, and the fingerlike horns.

The manta has another pair of unusual fins on its head. These fins, which may remind people of a devil's horns, unfurl to guide fish into the manta's wide mouth, located on the underside of the fish's head.

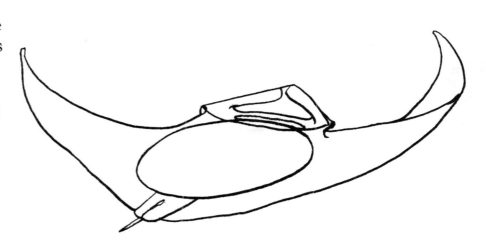

⑤ Now erase any unnecessary lines. To finish your manta, darken the top surface of the wing on the right, add a second line along the front edges of both wings to show the wings' thickness, and draw the gill slits on both sides of the animal's body. Detail your manta ray by lightly shading where the body and wings meet. Shade the tail, the horns, and along the wings as shown, and darken the eye and mouth.

The manta is known for its spectacular leaps out of the water. These jumps seem to happen most frequently in the shallow water of bays. The loud belly flop that the creature makes when it returns to the water may help knock off the parasites and remora fish that sometimes cling to its skin.

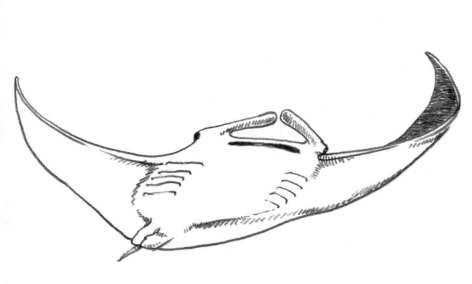

The Zebrafish is one of the most beautiful—and most dangerous—creatures in the ocean. It lives in shallow tropical and

① Begin by drawing a pear shape for the zebrafish's body.

Delicately striped in reddish brown, black, and white, the zebrafish usually grows to 7 or 8 inches long, although it can be as long as 18 inches.

② Next draw a blunted diamond for the tail and a tapered shape above the back as a guideline for the dorsal spines.

The danger of the zebrafish lies in its graceful spines. The 13 spines along its back all hide glands that contain a venom so powerful that it causes intense pain and sometimes even death in humans.

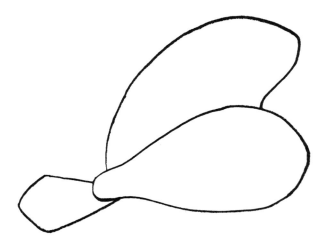

③ After drawing a sideways heart shape for the mouth, add broad guidelines for the zebrafish's pectoral fins.

It is hard to approach a zebrafish from a safe direction. That's because its dorsal spines are held at alternating angles, left and right, all along its back. When a spine punctures or even brushes against flesh, the spine's skin sheath is pulled back, and the venom gland in the spine's groove empties into the wound. There is no antidote. If enough venom enters a person's body, it can actually stop the heart.

MORE SCIENCE: In spite of the danger, zebrafish are so strikingly beautiful that many people like to keep them in home aquariums as pets!

④ Add a second line around the outside of the upper mouth and around the inside of the lower mouth. Then draw the nostril shapes, the eyes, and the two pointed horns.

The zebrafish usually feeds at night. It can position itself upside down, gently moving its fins so that smaller fish mistake them for waving plants or corals. When a fish ventures too close, the zebrafish quickly sucks it into its mouth.

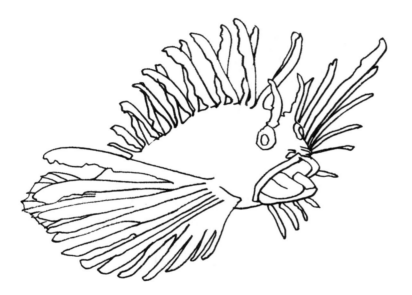

⑤ Now, using the outlines you made in steps 2 and 3, draw the curving, featherlike spines in the dorsal and pectoral fins. Draw the fish's tongue and lower jaw, and begin to add the few stripes that are visible on the tail. Erase all unnecessary lines on your zebrafish.

The zebrafish is not shy. When annoyed, it will stand its ground or even advance, head down, against a threatening animal or object.

⑥ Finally, fill in the stripes on the fins, the body, the face, and even the eyes. Fill in the centers of the eyes, and lightly shade in the mouth. Last, darken the zebrafish's two horns, and add a small flap hanging from the corner of its mouth.

The zebrafish has many names. In different parts of the world, it is also known as the lionfish, turkeyfish, tigerfish, or butterfly cod. These names refer to its coloring as well as to its long, graceful dorsal and pectoral fins.

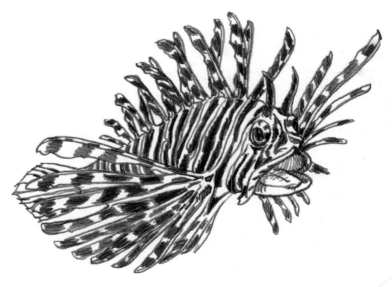

The Octopus is known for its large eyes and curling, grasping arms. While it may have the reputation of a frightening sea

① Start your octopus's body with an oval shape for the head.

The octopus, whose name refers to its eight arms (the Latin root octo- means "eight"), lives in oceans worldwide. Some species are only 2 inches long, while others have arms that span up to 32 feet. However, even large octopuses can be hard to see, since they live in natural rock crevices or in stone fortresses that they build as protection from predators.

② Next add the tip of the octopus's head on the left. The pocket shape you add on the right will become the place where the arms attach.

Considered prey by sharks, marine mammals, and even other octopuses, the octopus has developed ways to protect itself. To camouflage itself, it can change its skin color and even its pattern within seconds. When discovered by a predator, it can squirt out a thick, dark, inky fluid, then quickly jet away. The ink stays in a compact mass, and scientists believe it confuses the enemy, partly because of its strong scent.

③ Continue by drawing two large shapes that will outline the two "fans" of tentacles. Sketch in the tear-shaped valve through which the octopus takes in water.

The octopus, along with its close relative the squid, breathes by dilating the mantle of skin that covers its head and internal organs. That causes water to be sucked in through the tear-shaped valve. Gills then absorb the oxygen in the water. By squeezing the water out quickly through a tube, the octopus can propel itself through the water.

MORE SCIENCE: Octopuses live in fairly deep waters off the seashore, some species living up to 3 miles deep. Although the animal is seldom aggressive, its beak, which looks like an upside-down parrot's beak, can give a painful bite and, in some species, can inject poison.

monster, it is actually a shy and graceful animal that has more ways of hiding and escaping than attacking.

④ Now it's time to add the eight arms, tapering them to very fine tips. Notice how they curve and twist—you can curl your octopus's arms any way you wish. Add the large eye.

The octopus usually feeds on lobsters, shrimp, crabs, and clams, entwining its prey and grasping it with its suckers. It then cracks the prey's shell with its beak, located at the base of its arms.

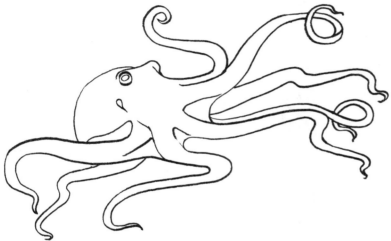

⑤ Draw in the oval pupil of the eye, and sketch in the webbing between the arms as shown. Erase the guidelines, as well as the unnecessary lines within the body.

Among the animals without backbones, the octopus's eyes are most similar to a human's.

⑥ Finish your octopus by shading the webbing and darkening the eye and the water-intake valve. Give your octopus texture by adding stipple along the arms and body, increasing the size of the stipple on the head. Finally, draw rows of raised oval suckers on the inner side of the arms, making them smaller toward the tips of the arms.

The octopus's sucking disks may be unpleasant for its prey, but they are most useful to the octopus. There are approximately 240 disks on each arm, depending on the species. The disks help the octopus identify objects by touch, and also help it in climbing rocks and grasping prey.

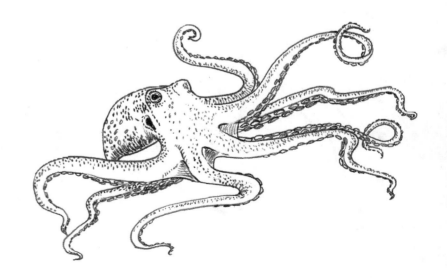

The Pearly Nautilus is recognized by its beautifully marked brown-and-white shell. Surprisingly, the

① To begin your pearly nautilus, draw an oval that will serve as an outline for the shell.

The pearly nautilus gets its name from the lustrous lining of its flattened, coiled shell, which grows to about 6 inches across. The creature dwells in the southern Pacific Ocean, from about 80 feet to nearly one-third of a mile underwater.

② Next overlap the oval with a pie-shaped wedge as shown.

Like its relatives the octopus and the squid, the pearly nautilus feeds on crabs, cracking open their shells with its powerful beak, which is located at the center of its tentacles.

③ Continue creating your nautilus's shell by drawing a spiral in the center of the oval. Add a curved line from the pie shape to the spiral for the shell's opening, and draw a wavy line inside the pie shape as shown.

The nautilus has two eyes, each of which is located on the end of a stalk, just as the eyes of a snail are.

MORE SCIENCE: The pearly nautilus has no suction cups or ink sac, but its arms have adhesive pads that face the opening of the mouth. These pads secrete a sticky substance that's used for holding prey.

nautilus is a relative of the octopus and squid and is a direct descendant of sea animals that lived 400 million years ago—before the dinosaurs!

④ Next add the one flowerlike eye visible in this drawing (the stalk on which this eye sits is not visible). Within the pie shape, sketch the curving outlines of the nautilus's hood.

The fleshy hood that lies against the curve of the nautilus's spiral shell forms a protective flap when the animal retreats into its shell.

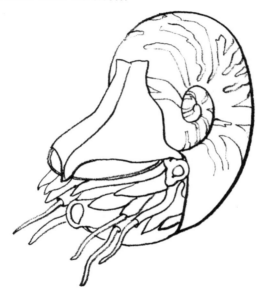

⑤ Now draw the leaflike tentacles, some with their thin, stringy centers extended. Don't forget to add the large water siphon among the tentacles, and sketch the outlines of the white stripes that decorate the shell. Erase all the unneeded lines around the shell and the hood.

When the nautilus is on the move, as many as 90 tentacles protrude from inside its shell to enable the creature to crawl along the ocean floor.

⑥ Darken the area below the eye as well as the eye itself, leaving a small white center. Add shading around the white markings on the shell, and add markings on the hood to show bumps and ridges. Use curved hatching lines on the lower part of the shell and on the tentacles to show their roundness. Finally, add dark shading around the base of the shell, and draw a thin line around the hood and shell as shown.

The nautilus can propel itself through water the same way squid and octopuses can—by dilating a mantle of skin, sucking in water, then forcing the water out through its siphon.

The Elephant Seal 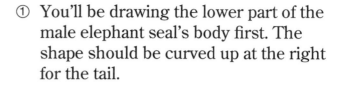 gets its name from the male seal's drooping, tubelike nose, which can grow to about

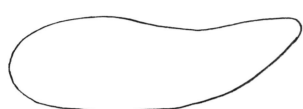

① You'll be drawing the lower part of the male elephant seal's body first. The shape should be curved up at the right for the tail.

The male elephant seal can grow 15 to 20 feet long and weigh more than 8,000 pounds—as heavy as a large automobile! It is one of 18 species of earless seals (also called the true seals). It is also the largest of the pinnipeds, the group of animals that includes fur seals, sea lions, and walruses.

② Draw a large almond shape for the thick neck and a curved triangle for the tail flippers.

The seal's blubber, or fat, can be 6 inches thick. The blubber helps the animal in two important ways: it insulates the seal from the cold, and it stores the energy that the seal needs during times when it cannot feed— while mating and bearing pups.

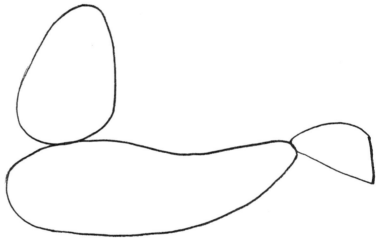

③ After you sketch a small, round shape for the nose, draw the jagged inner edge of the tail flippers and two stubby shapes for the front flippers.

This sea mammal's flippers have bones that correspond to those of a human arm and hand, and fingernails that tip each of five fingers! The seal's fingers, however, are more elongated than those of humans, and they are connected by a thick webbing adapted for swimming.

MORE SCIENCE: Throughout the 19th century and much of the 20th, elephant seals were killed for the oil in their blubber. Even as early as 1885, elephant seals were nearly extinct. Now that the hunting of these animals has been banned, seal populations are on the rise.

④ Next smooth the connection between the thick neck and body, and the tail flippers and body. Draw a connecting line between the drooping nose and the top of the seal's head. Sketch a short line for the mouth, and add the base of the front flipper closest to you.

The teardrop shape of the elephant seal is well adapted for a life of diving and swimming. And its backbone, which has 7 to 9 more vertebrae than the backbone of a human, is very flexible, allowing the creature to maneuver well in the water.

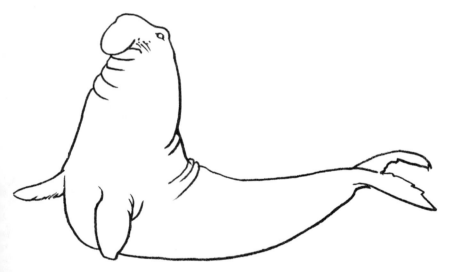

⑤ Indicate the eye and the flesh folds on the neck, the back, and under the front flipper. Begin to sketch the whiskers and the texture around the far flipper. Now erase all unneeded lines around your seal.

The elephant seal pup weighs about 50 to 60 pounds at birth, and it can gain 10 pounds a day just on its mother's rich milk. After one month the pup is weaned, and after two months it is able to feed itself by diving for fish and crustaceans.

⑥ Your majestic elephant seal is almost done. Use short hatching strokes to shade the body and flippers to show the seal's short fur. Add lines and marks for wrinkles and scars around the neck. Draw the eyebrow hairs, darken the eye and whiskers, and shade the nose.

All seals have fur to help keep them from getting too warm or too cold while on dry land. In the water, their blubber helps keep the animals warm.

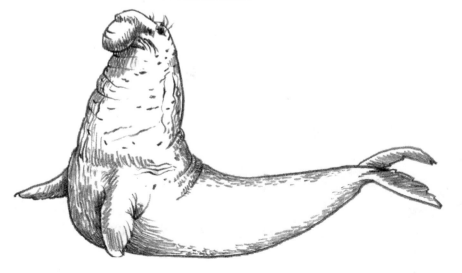

The Angelfish is one of about 80 species of patterned tropical fish that

① Start your angelfish by drawing its main body shape—a circle—flattened slightly at the bottom.

This graceful tropical fish has a flat shape and grows to more than 1 foot in length.

② Two partial circles indicate the upper and lower fins. Add a bump for the mouth area.

Since it is neither fast swimming nor agile, the angelfish feeds on stationary animals, such as sponges. For protection, this creature relies on its ability to hide, made easier because of its flat shape and because its coloring helps it blend in with its background.

③ Now draw a fan shape for the tail and a triangle for the pectoral fin. Add a long shape for the lower fin (the angelfish has two of these lower fins, but you can only see one of them in this illustration). Sketch a wavy line through the mouth area.

The angelfish is related to the perch, one of the spiny-finned fish. Its spines are near its gills.

MORE SCIENCE: When angelfish are ready to reproduce, the male and female select a rock and carefully clean all of the algae from it. The female then lays her eggs, which stick to the surface of the rock, and the male fertilizes them.

④ Connect the tail and the upper fin to the fish's body. Sketch in a small fin between the two lower fins. Add a backswept point on the upper fin, and draw a notch for the mouth.

Probably the most brilliantly colored of animals both on land and sea, this particular fish is electric blue with a golden yellow tail, yellow stripes, and a black mask and gill patch.

⑤ Next draw double lines to outline the dark markings on the head and gill area, and add two circles for the eye. Erase all extra lines.

This angelfish changes its color and its pattern as it matures. The young angelfish is black with curving blue-and-white stripes that run vertically. It also has a large white ring near the tail. As the young fish matures, these patterns fade, and the bright adult colors and horizontal stripes begin to appear.

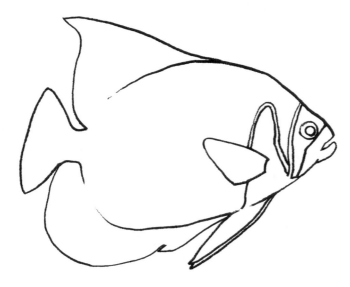

⑥ Put the finishing touches on your angelfish by drawing stripes on the body and fins. Detail the forward fins and tail, and fill in the dark areas over the eye and gills. Add a thin line of dots around the pointed back end of the upper fin, and create a jagged edge around all the fins as shown. Finally, add teeth and light shading around the mouth.

Because many kinds of young angelfish change color one or more times before becoming adults, scientists overestimated the number of species. Now we know that about 80 different varieties of angelfish exist.

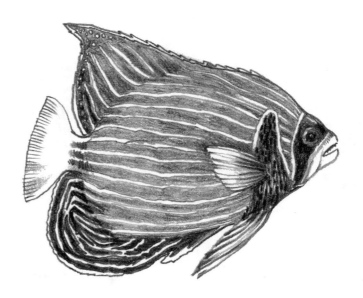

The Japanese Spider Crab is a rare animal that lives in the western Pacific Ocean

① Your spindly Japanese spider crab begins with a small oval for the body.

The Japanese spider crab has five pairs of legs, with small claws on the front pair. It can measure an amazing 19 feet from one outstretched claw to the other.

② Next add two small ovals above the body for the eyes. Then draw two balloon shapes that will serve as guidelines for the legs.

This species of crab cannot swim. Instead, it crawls slowly along the ocean floor.

③ Now sketch in the two front legs on the right side of the crab and all five legs on the other side. Drawing the legs will be made easy if you start with a single line for each leg, then double and divide the lines to create jointed legs as shown. End each leg with a point, and notice that the point on either front leg is split to create claws. Add the edge of the mouth area, too.

Spider crabs feed on worms, mollusks, and other crustaceans. Their claws can easily crack open prey.

MORE SCIENCE: Species of crab can be found in a variety of areas: in the ocean depths, on the seashores, and even in freshwater rivers. Some crabs are bottom dwellers, while others swim using paddle-shaped hind legs. One land-dwelling crab can even climb trees!

④ Complete the legs by adding three back legs on the right side of your drawing. Don't forget to add the short antennae, the eye stalks, and the lower, ribbed edge of the body.

The Japanese spider crab has a hard shell for protection and uses its coloring as camouflage. Occasionally, it will cover itself with seaweed or bottom-dwelling animals such as anemones to disguise it from the octopus and squid, its natural predators.

⑤ Indicate the rough upper edge of the shell, the additional spikes, and the center of the mouth area. Erase the guidelines, as well as any extra lines.

Like other crustaceans, the Japanese spider crab can regenerate, or grow back, legs that it has lost.

⑥ Finish your crab by darkening the eyes, the mouth area, and the underside of the body. Use stipple to create a splotchy pattern on the legs and a rough surface on the shell. Don't forget to shade the spikes to give them a three-dimensional look.

Even though they have very long legs, giant spider crabs are fairly slow and sluggish. That is why they feed on meals of dead fish rather than hunt actively.

The Hawksbill Turtle got its name from its birdlike jaws. Even if you have never seen the whole turtle,

① First draw an oval for the turtle's body. The oval should be pointed at the lower end for the animal's tail.

This harmless marine reptile, which lives in the tropical waters of the Florida Keys, the Bahamas, the Gulf of Mexico, and the Indian Ocean, is the smallest of the five species of sea turtles. A mature hawksbill weighs less than 100 pounds and measures about 3 feet from the front to the rear of its shell.

② Add the almond-shaped head and an outline inside the oval to create a border on the shell.

Western species of hawksbill turtles forage for food near reefs or rocky crevices. They seem to prefer a diet of bottom-dwelling sponges.

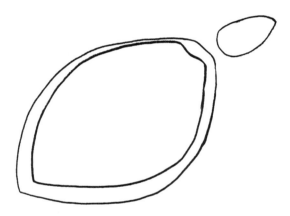

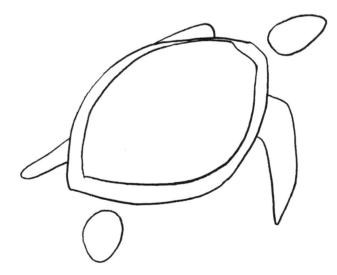

③ Next add the long, narrow front flipper, an egg shape for the rear flipper, and smaller shapes for the two far flippers.

The hawksbill's broad, thin, front flippers, which have one or two claws along their edges, propel this turtle through the water with winglike "flapping" motions. The rear flippers are used for steering.

MORE SCIENCE: Hunting, pollution, and human activity on beaches now threaten the hawksbill's existence. In the sea, many turtles are caught and drowned in shrimp fishermen's trawls. Even though the turtle has been protected as an endangered species for the past few years, researchers aren't sure whether the hawksbills are recovering their numbers.

you may have seen its shell. Beautifully patterned in red, brown, and black, the shell is called "tortoise shell." Used in jewelry, it has been prized for centuries.

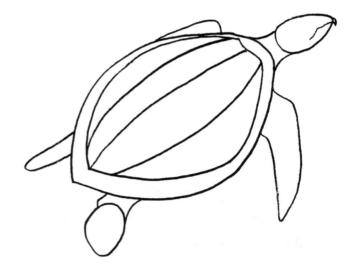

④ Join the rear "foot" to the body, and sketch the brow and upper jawline. Draw curved guidelines on the shell, which will help you draw the overlapping plates on it.

The turtle's shell is among the toughest in the animal kingdom. It consists of an upper shell and lower shell attached together at the sides. The inner layers are bony, and the outer layers resemble tough fingernail material.

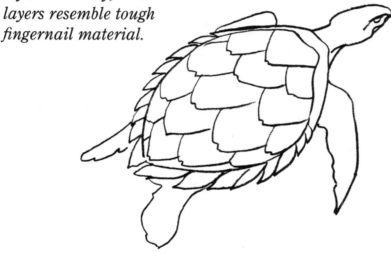

⑤ Sketch in the overlapping shell plates, then transform the shell's border into leaflike plates. Indicate the turtle's eye. Add the bumpy line that defines the lower part of the head and neck. After sketching the rippled edges of the flippers, erase all unnecessary lines.

Like other marine turtles, the female hawksbill comes ashore to lay her eggs. When the young turtles hatch, they must dig out of their sandy nest and find their way to the sea, where they will spend the rest of their lives.

⑥ Now shade the overlapping plates in rich tones. Use dark shading at the front of each plate and lighter shading at the rear to make the plates stand out. Be sure to leave some white space on the plates where shown. Fill in the eye and detail the squarish markings on the turtle's head and flippers. Finally, add shading around the leaflike border plates as shown.

Even though turtles such as the hawksbill live in the water, they still have lungs and must come to the surface for air.

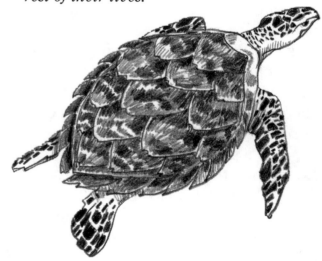

DRAWING TIP: By incorporating dark shading and light shading with white space, you give your hawksbill's shell a rounded, textured look. This technique can be applied to other animals you draw, too.

Backgrounds

Once you have completed a drawing, you may want to put your animal in a setting. For most of these animals, the background is the sea, but you can add all sorts of things to make the scenery interesting. Scuba diving magazines or books on underwater life will show you environments in which marine animals live. Or, use your imagination! Here are some suggestions for creating different settings.

MAGAZINE BACKGROUNDS

If you like to cut and paste, ask your family for some old magazines you can cut up. If your animal lives near the seafloor, cut out pictures of rocks, seaweed, or grasses. Or cut out different patterns and trim them so they're shaped like coral, rocks, or even a cave. This will give your picture an interesting abstract look. And you don't have to fill the entire page. A few groupings to the side or below the fish will give the impression of a whole scene.

PAINTED BACKGROUNDS

You don't need a paintbrush to add these painted backgrounds! To create bubbles, dip the end of a drinking straw into some paint and print streams of bubbles around your sea creature. You can make smaller bubbles by using the ends of tiny macaroni, or larger ones with large macaroni. Cut a piece of sponge, dip it in paint, and stamp it on your picture to create a coral or rock texture. Or try crumpled wax paper or a paper towel to do the same. Be sure not to get these too wet, though, or they won't work well. Look around the house for other printing tools, such as old wooden spools, corrugated board, or cut pieces of Styrofoam.

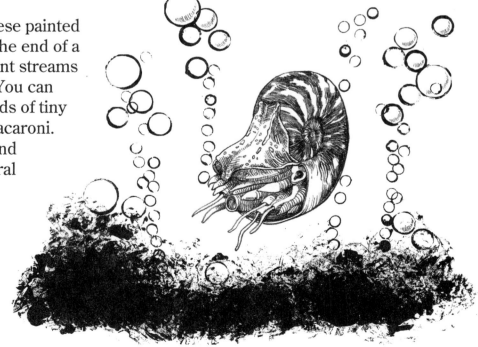

TEXTURED BACKGROUNDS

If you want to create a textured background, you'll need to draw your animal on a thin piece of paper. Place a textured object (such as sandpaper) under the section of your paper where you want the texture to appear. Now grab a pencil with a soft lead. Then, using the side of the pencil lead, rub lightly and evenly over the area. To create an undersea plantlike texture, spread out several playing cards into a fan and rub your pencil over the edges. For other cool textures, try using window screening, rough wood, a kitchen grater—anything you can imagine!

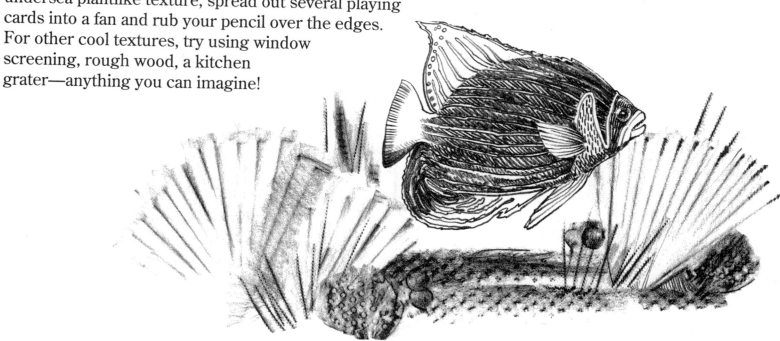

SHADOWED BACKGROUNDS

By adding shadows in the right places, your animals will leap off the page! Imagine where the shadow of your animal would fall underneath its body, fins, and tail. Then fill in those areas with a dark pencil. If the animal in your drawing is swimming along the bottom of a shallow seafloor, just as this manta ray is, sketch a shadow shape on the sand or rocks below your creature. You might want to add shadows to some of the rocks or plants, too.

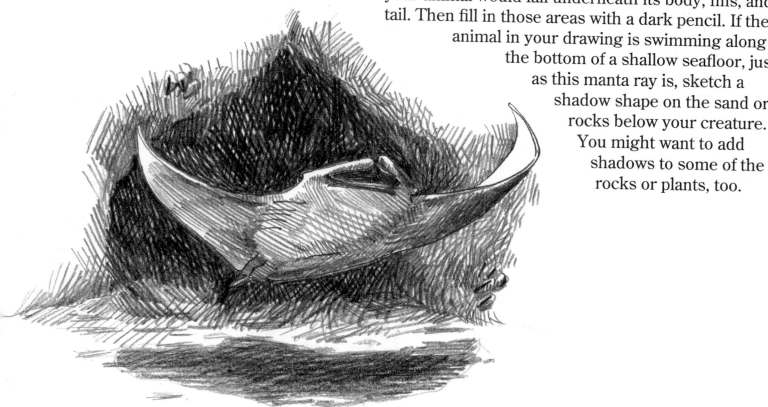

57

Bringing Your Animal to Life

Here are more tips on how to put life into your drawings. Keep in mind that the most realistic drawings combine several finishing techniques. You can practice and experiment with your own favorite combinations!

CONTOUR DRAWING

Even if you don't plan to fill in your drawing with color or texture, you can make your animal look more solid by changing the darkness and width of their outlines. For example, note the difference in line weight within the drawing of the killer whale. The lower edges of the animal are thicker and the upper outline is thinner, making the killer whale look as if it will leap right off the page!

CAST SHADOWS

Your drawings will look much more realistic if a surface is added for the animals to rest on, swim over, or float above. If your animal is resting on the seafloor, as this octopus is, imagine what kind of shadow it might cast on the ground if light were shining on it from above. Draw the shadow as a dark shape, making it thinner under narrow body parts (in this case, under the tentacles) and fatter under wider body parts. With a swimming fish you can show its shadow falling on the ground—even when the animal isn't itself touching the ground. Remember that shadows can appear not just on the ground, but on the underside of animals, too.

LIGHT FIGURE, DARK BACKGROUND

You'll be surprised by how rounded your animal looks if you simply darken the space behind it. By darkening the space behind this great white shark, you can create a rounded, three-dimensional effect. You can imagine the animal swimming in front of an undersea cave or against the darkness of the ocean depths. Of course, if you add texture to the animal, the effect is even stronger—as with the light hatching on the great white!

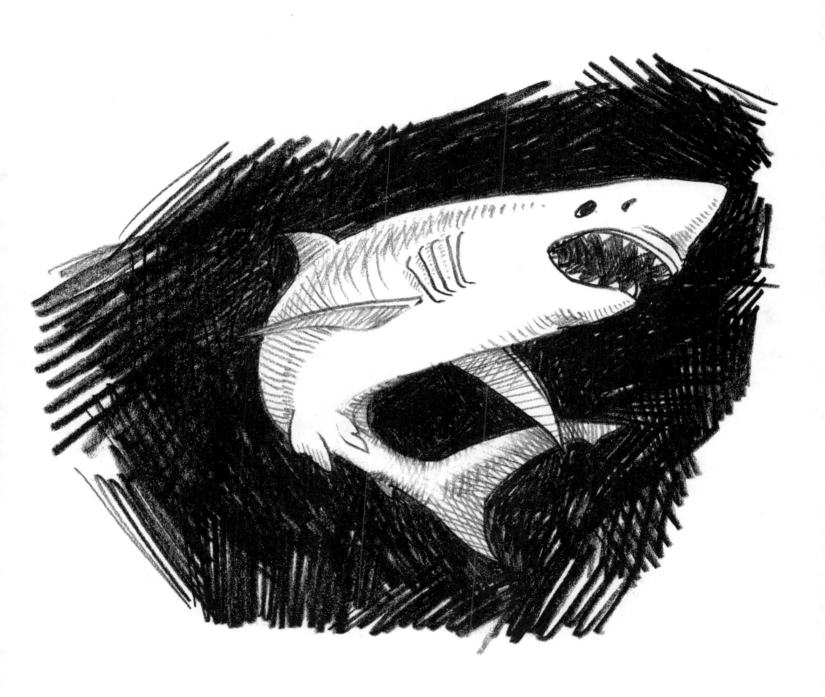

Making Your Animal Seem Larger (or Smaller)

How do you make an animal in a small drawing seem larger? Or an animal in a huge picture seem smaller? The following techniques will show you how.

THE HORIZON LINE

To show how big your creature is in a drawing, add a ground line or horizon line across your picture. If your animal is underwater, the line can indicate where the water background meets the seafloor. In real life, the horizon line is on the viewer's eye level. So, if the top of the sea creature in your picture is much higher than the horizon line you drew—as with this sailfish—the creature will appear large to the viewer. If the horizon line is near the top of the page and the animal is drawn below the horizon line, the animal will appear smaller.

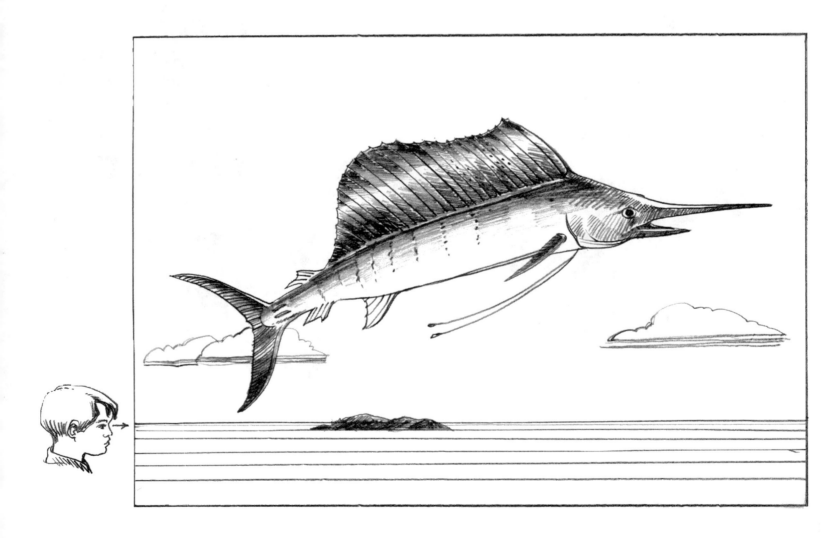

ADDING OBJECTS FOR SCALE

Another way to indicate your animal's size is to include objects whose size most people know. People know that coins, for instance, are small. Drawing them almost as wide as a lobster's claw indicates the small size of the lobster. Conversely, if you draw a lobster trying to fit on top of a pirate's chest, the viewer will see your lobster is huge! For fun, try adding a tiny scuba diver to your drawing. In doing so, you can make even a goldfish look like a huge monster!

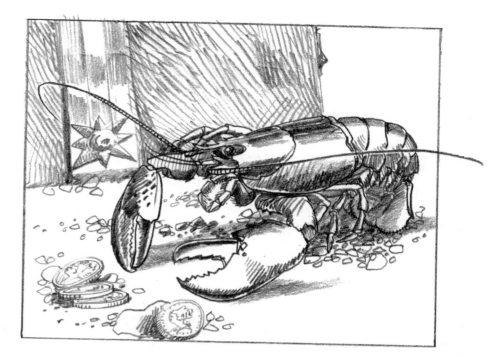

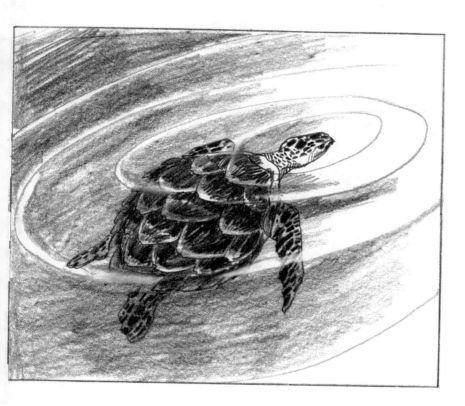

POINT OF VIEW

You can also show the approximate size of an animal by drawing it from a certain perspective. If you were swimming deep in the ocean, you could see sea creatures from almost any angle. If you saw a hawksbill turtle swimming below you, it would seem smaller than you. On the other hand, if you were looking at its belly from underneath, it would seem larger. By drawing your animal from either of these perspectives, you can give an impression of its size.

Tips on Color

Your picture will stand out from the rest of the crowd if you use these helpful tips on how to add color to your masterpiece!

TRY WHITE ON BLACK

For a different look, try working on black construction paper or art paper. Then instead of pencil, use white chalk, white prismacolor pencil, or poster paint. With this technique, you'll need to concentrate on drawing the light areas in your picture rather than the dark ones. Because many sea creatures, such as this deep-sea anglerfish, live deep down where the water is inky black, this technique is just right for drawing them.

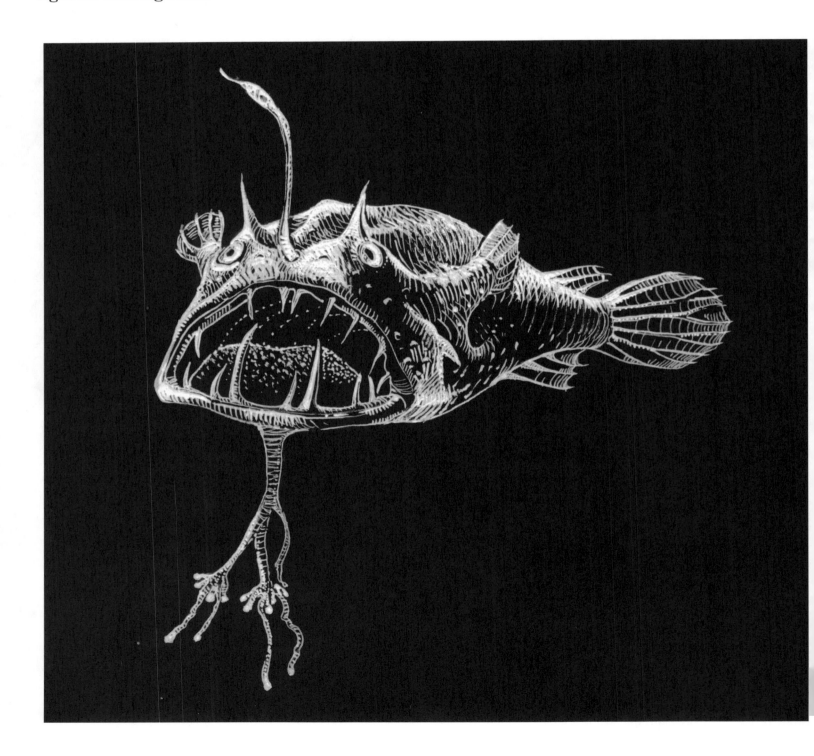

TRY BLACK AND WHITE ON GRAY (OR TAN)

You don't need special gray or tan paper from the art store for this technique. Instead, try cutting apart the inside of a grocery bag or a cereal box. This time, your background is a middle tone (neither light nor dark). Sketch your animal in black, then use white to make highlights. Add black for the shadows. Don't completely cover up the tan or gray of the cardboard. Let it be the middle tone within your illustration. With this technique, your pictures can have a very finished look with a minimal amount of drawing!

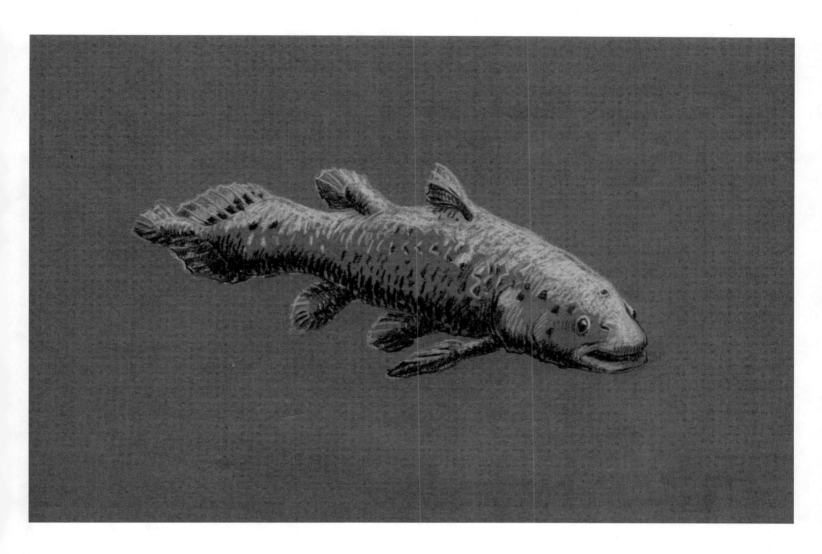

TRY COLOR

Instead of using every color in your marker set or your colored pencil set, try drawing in black for shadows, white for highlights, and one color for a middle tone. This third color blended with the white creates a fourth color. You will be surprised how professional your drawing will look.

63

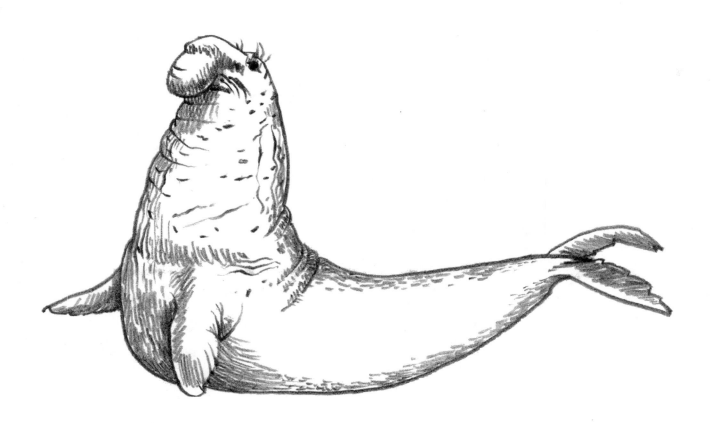